Stoney Creek Ontario in Photos, Saving Our History One Photo at a Time

Photography
by Barbara Raué
2012

Series Name:
Cruising Ontario

Book 6: Stoney Creek

Cover photo: Battlefield House taken from Stoney Creek Battlefield Monument

Series Name: Cruising Ontario

Book 1: London
Book 2: Dundas
Book 3: Hamilton
Book 4: Oakville
Book 5: Chesley
Book 6: Stoney Creek
Book 7: Waterdown
Book 8: Owen Sound
Book 9: Mount Forest
Book 10: Dundalk

Other Books by Barbara Raue

Coins and Gems

Arrows, Indians and Love

The Life and Times of Barbara
Volume 1: Inventions That Have Enhanced My Life
Volume 2: Entertainment That I Have Enjoyed
Volume 3: East Coast Trip 2009

Stoney Creek

Stoney Creek is located on the south-western shore of Lake Ontario. It was settled by Loyalists after the American Revolution. The Battle of Stoney Creek during the War of 1812 occurred near Centennial Parkway and King Street. In a surprise night-time attack, the outnumbered British overwhelmed the Americans and forced their retreat to Forty Mile Creek (the present location of Grimsby). In this forty minute battle, hundreds were killed and the two American Generals were captured. Battlefield Park has a monument and museum to preserve the history of this area.

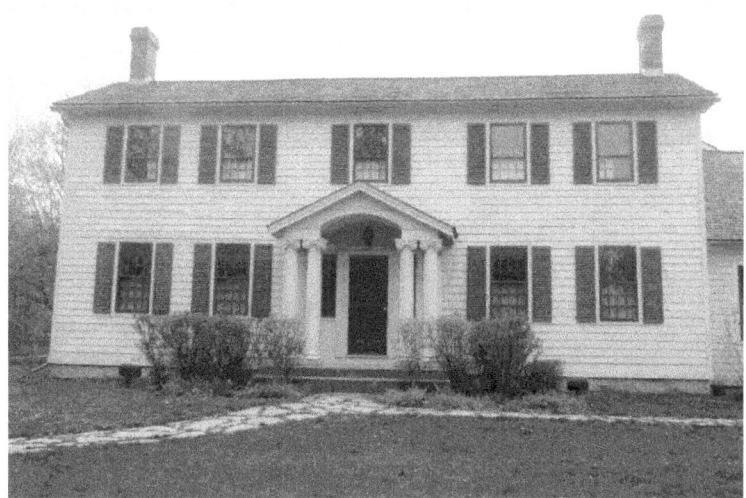

The Nash-Jackson House was originally located at the northeast corner of King Street East and Nash Road in Hamilton. The house was built in 1818 in the Georgian style. The house was moved to Stoney Creek Battlefield Park in 1999.

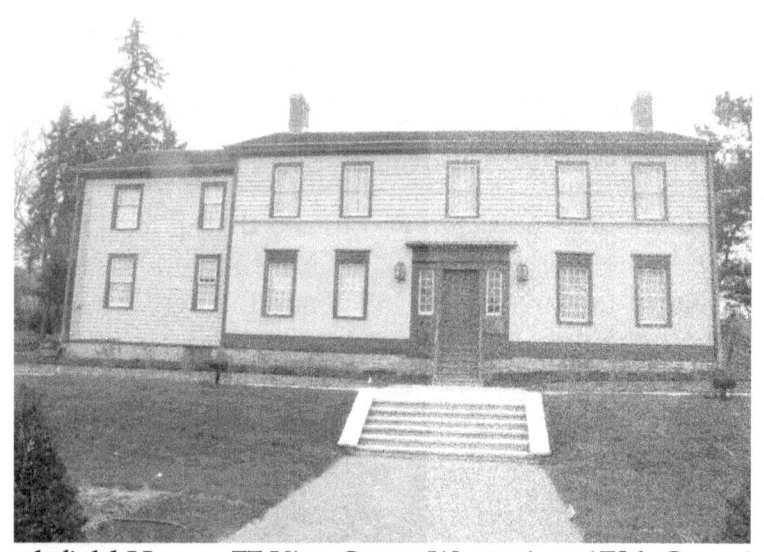

Battlefield House, 77 King Street West, circa 1796, Georgian style

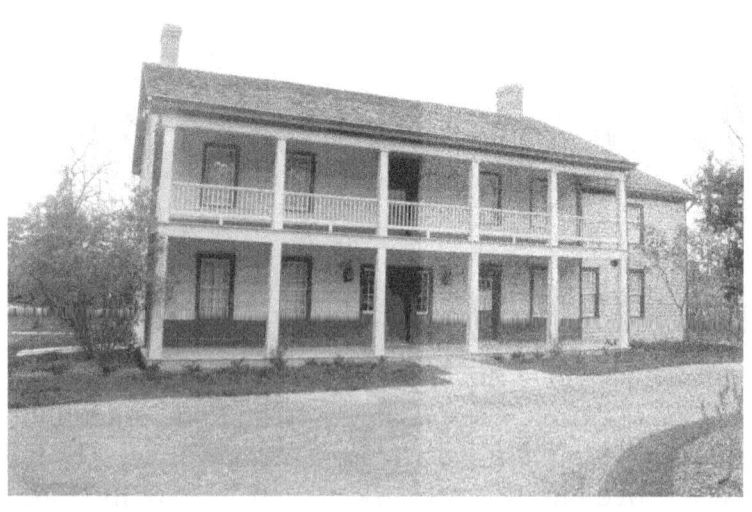

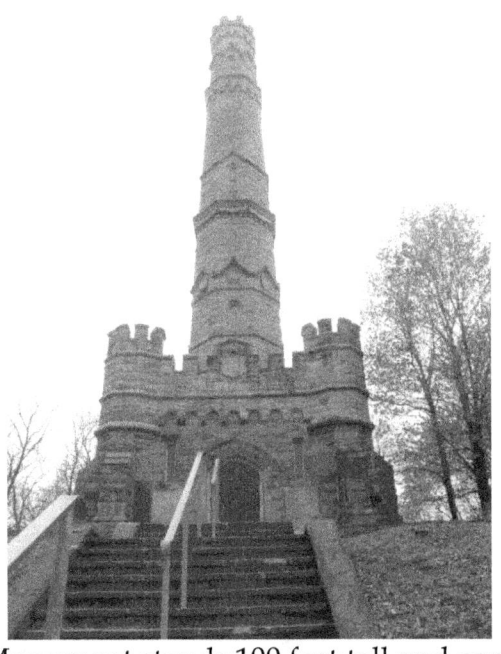

Battlefield Monument stands 100 feet tall and commemorates a century of peace between the British and the Americans.

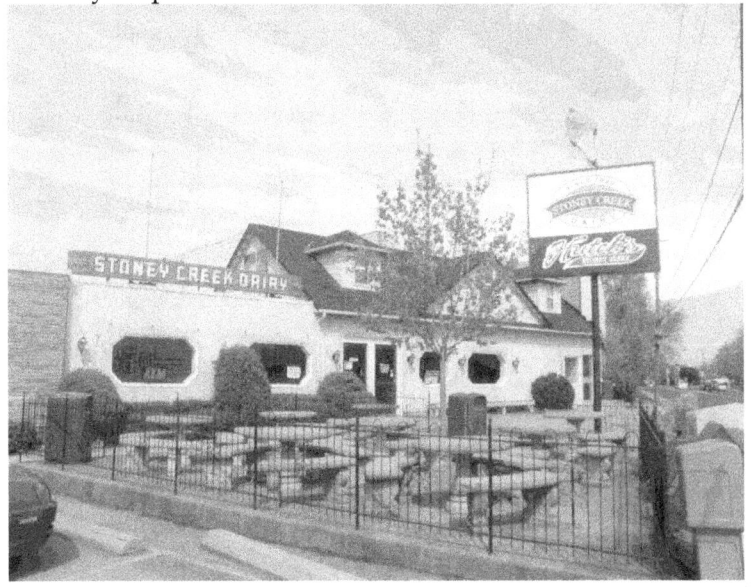

The Stoney Creek Dairy Bar, 135 King Street East, opened in 1941 to serve frozen treats. It closed in 2012.

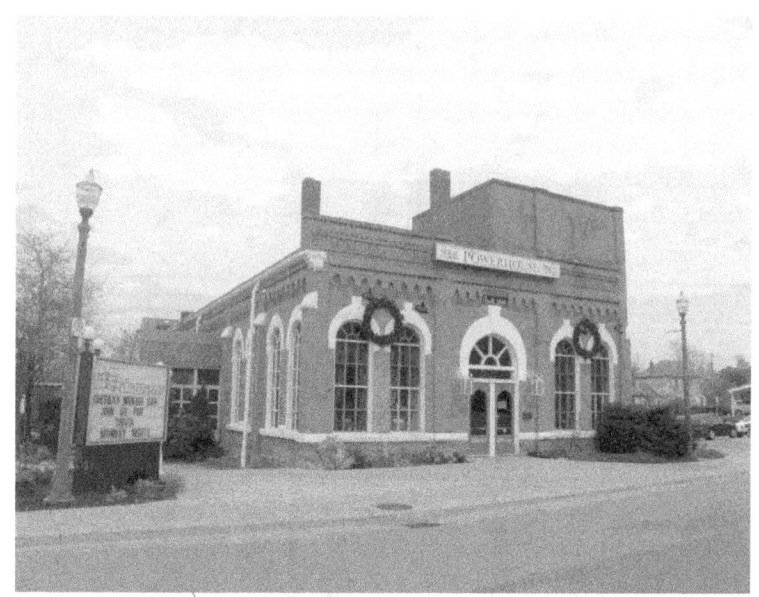

The Powerhouse is a historical landmark at the centre of Stoney Creek, 21 Jones Street. It provided power for electric rail lines in the 1890s. Now it is a restaurant.

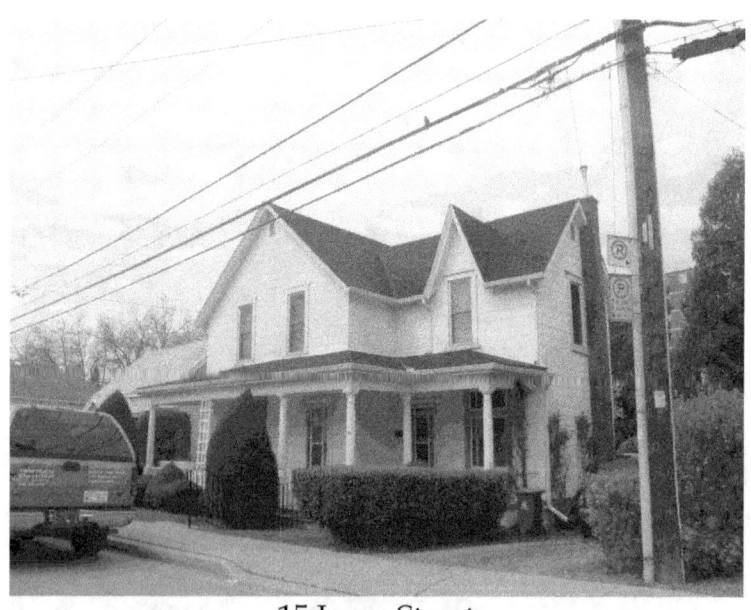

15 Jones Street

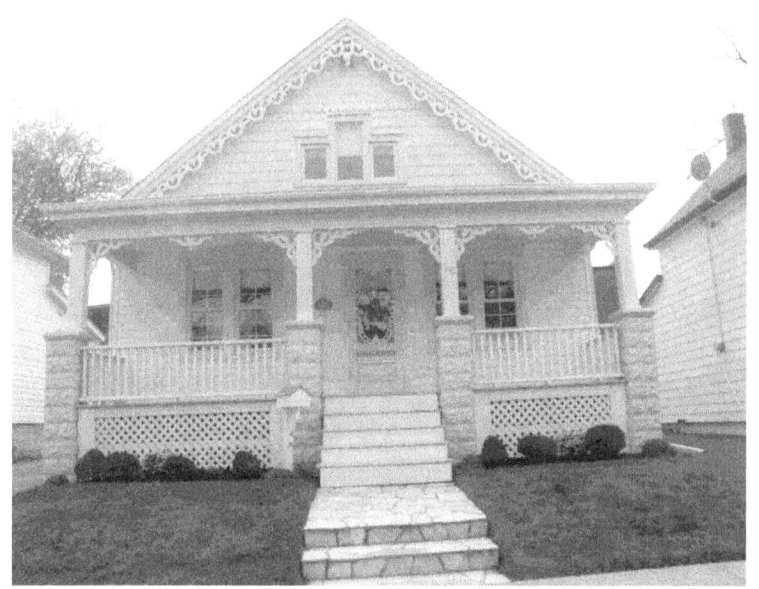

16 Jones Street

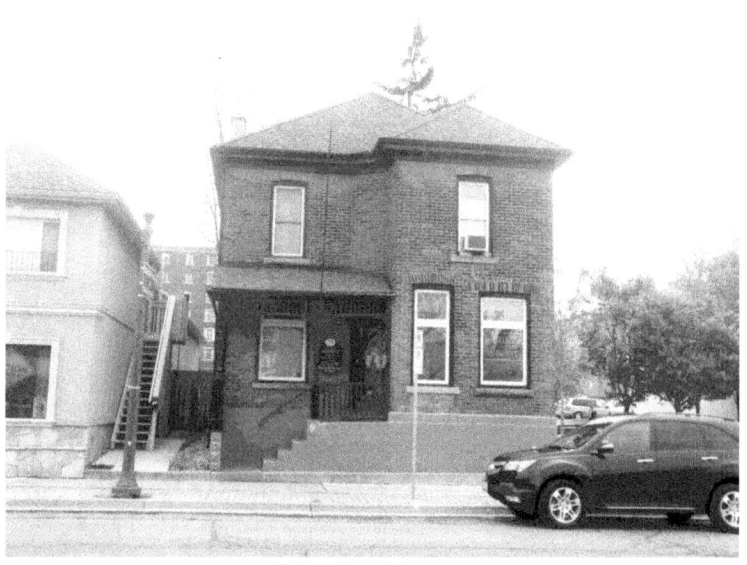

26 King Street

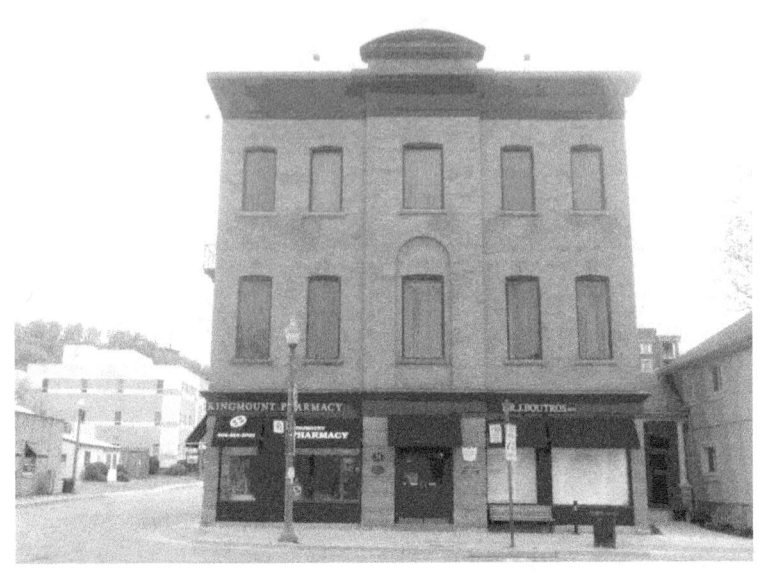

Century Square - 1901

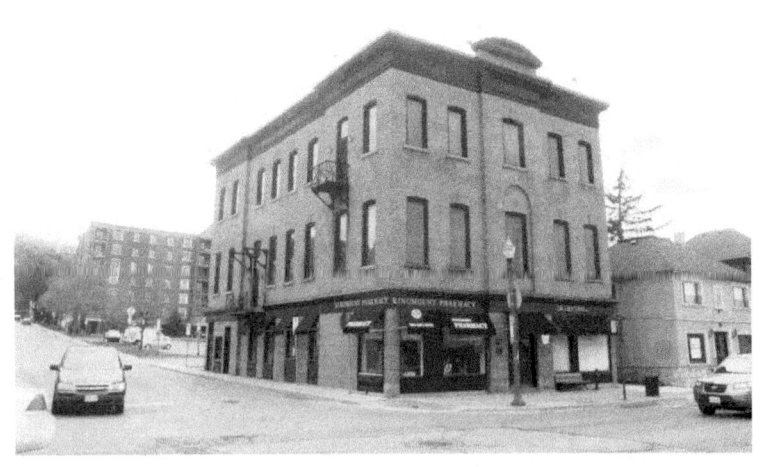

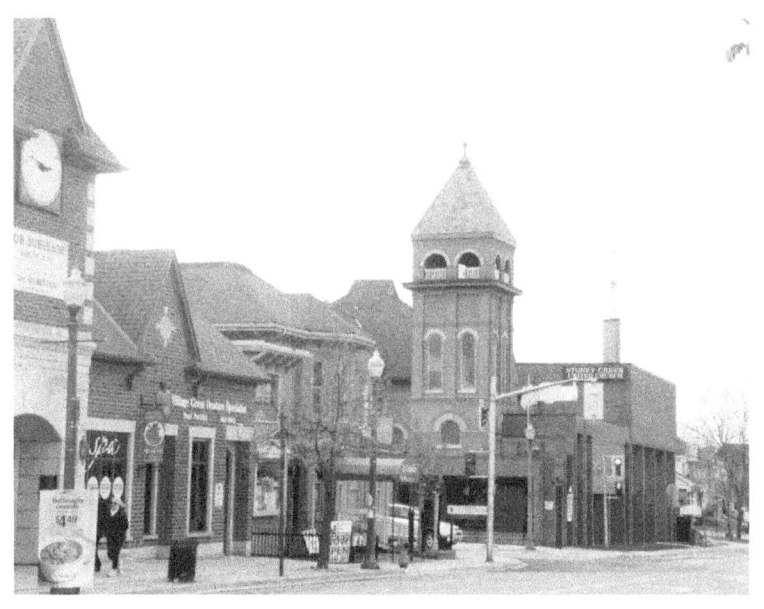

Downtown Stoney Creek

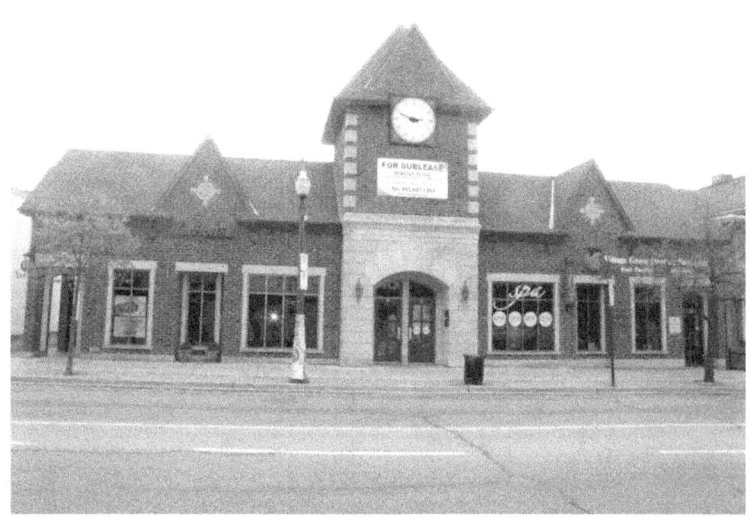

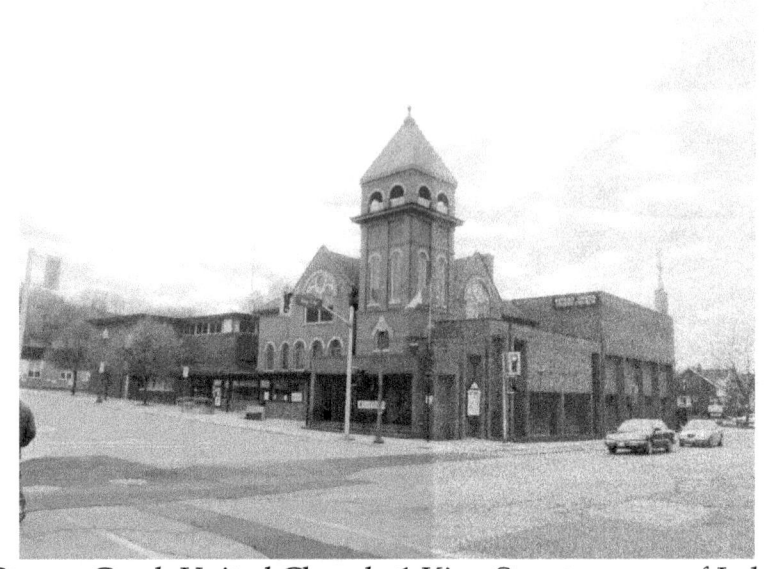

Stoney Creek United Church, 1 King Street, corner of Lake Avenue, founded in 1792

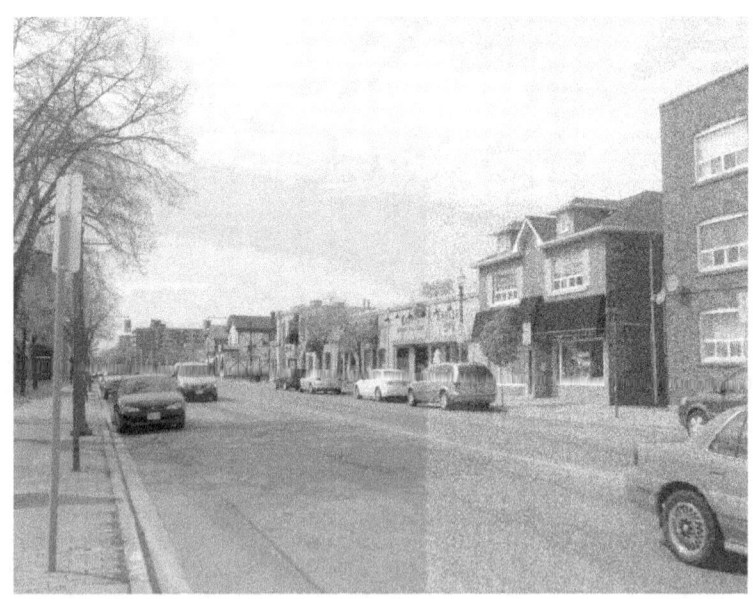

King Street

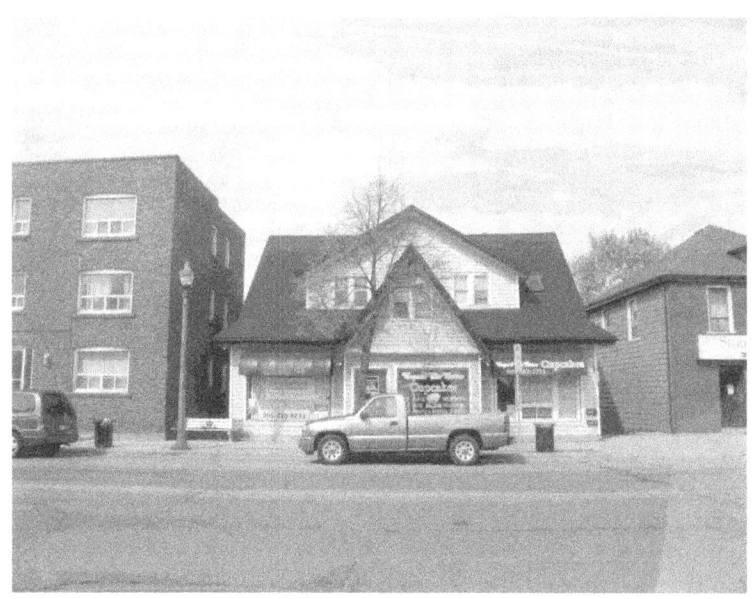

King Street

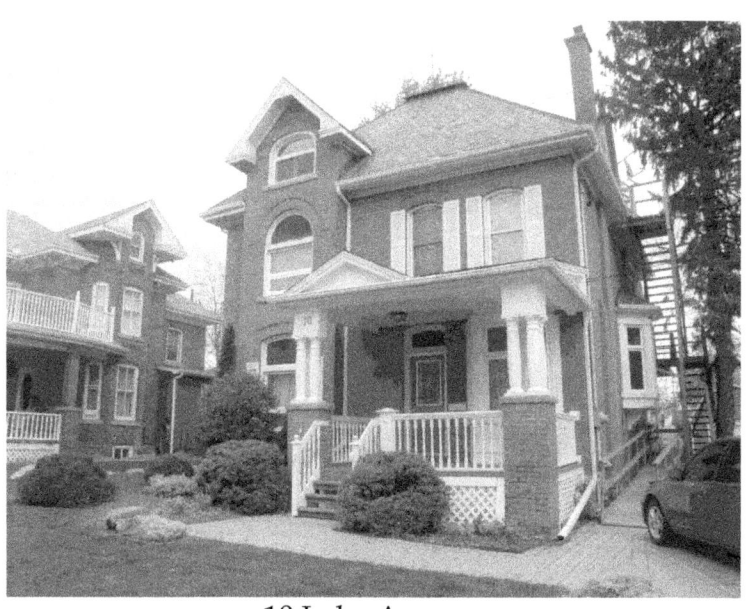

10 Lake Avenue

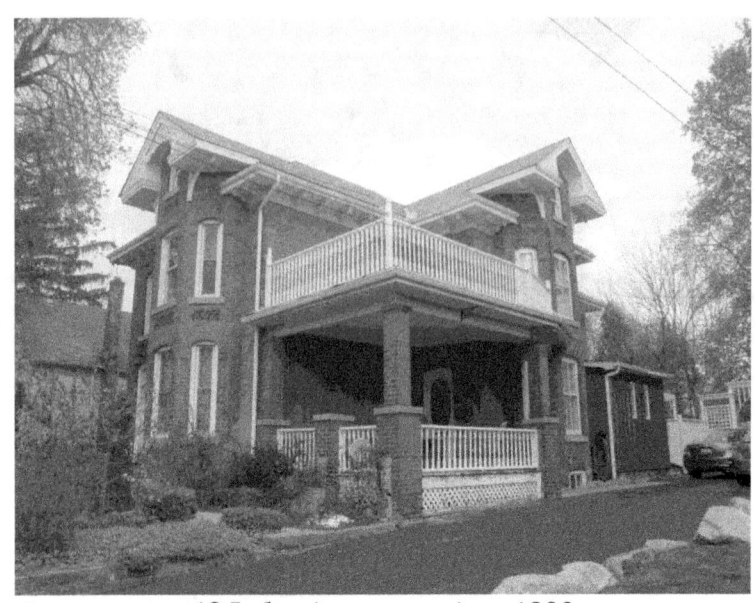

12 Lake Avenue – circa 1890
Former Methodist Parsonage

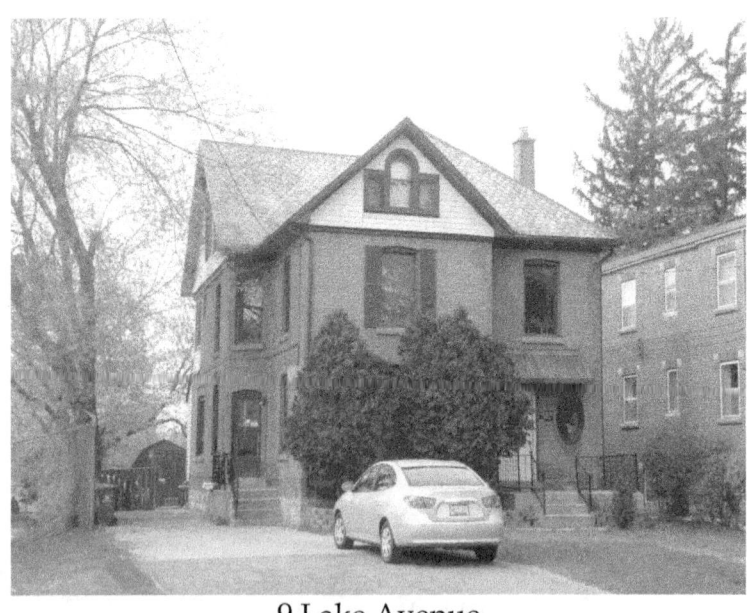

9 Lake Avenue

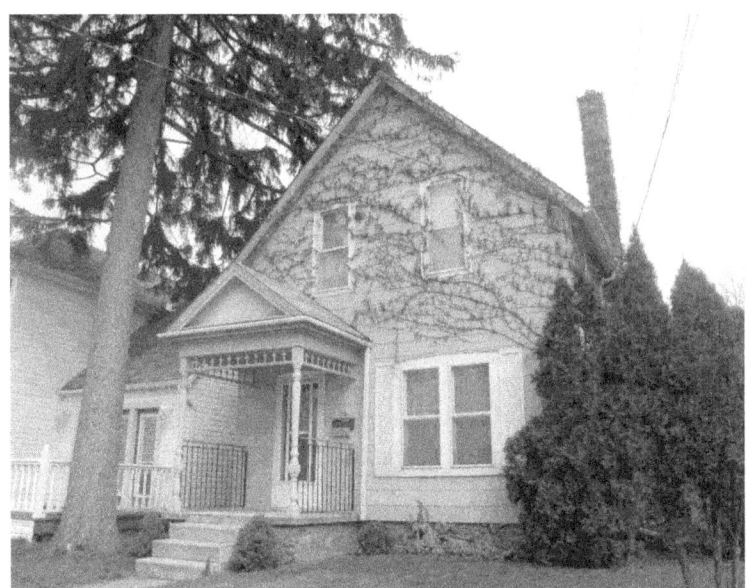

14 Lake Avenue

16 Lake Avenue

13 Lake Avenue

18 Lake Avenue

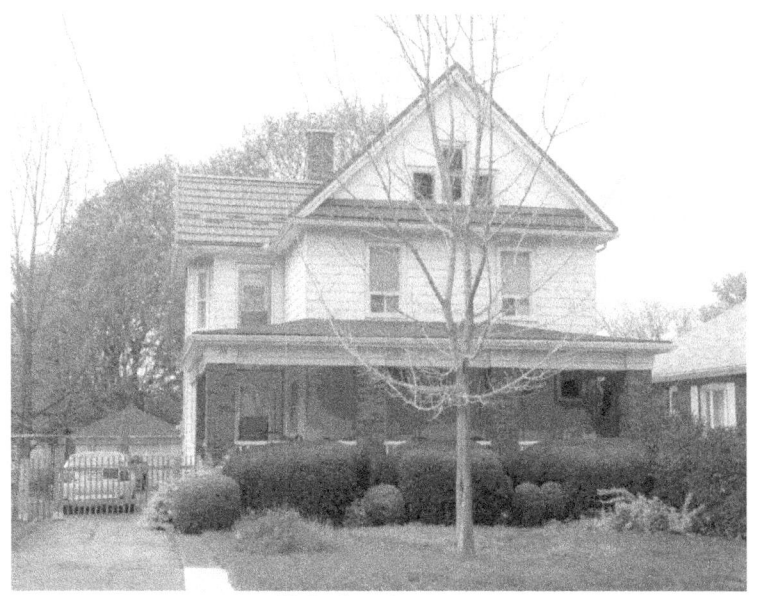

15 Lake Avenue

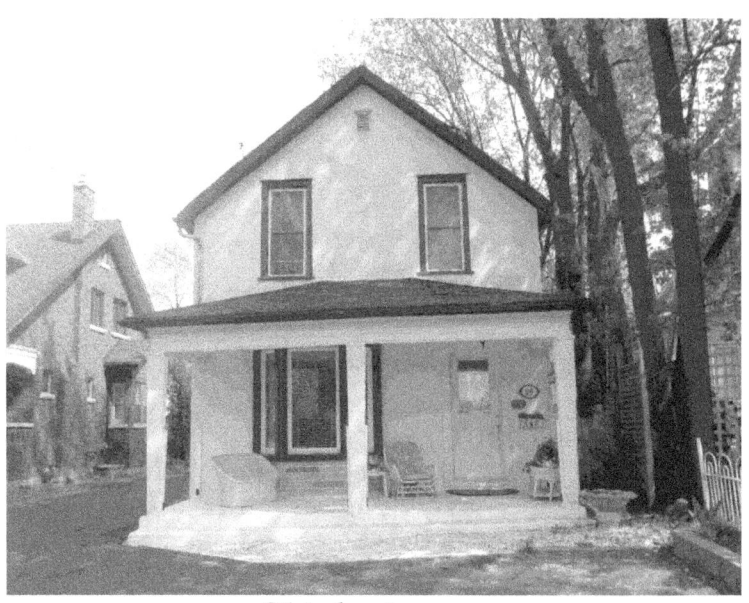

26 Lake Avenue

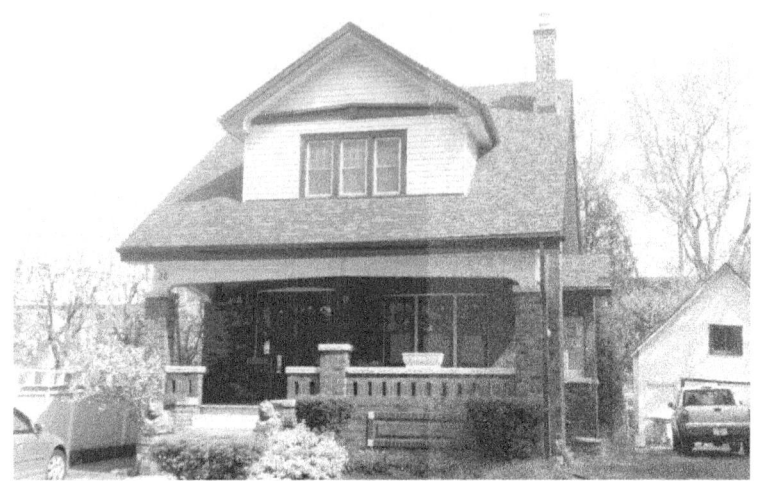

28 Lake Avenue

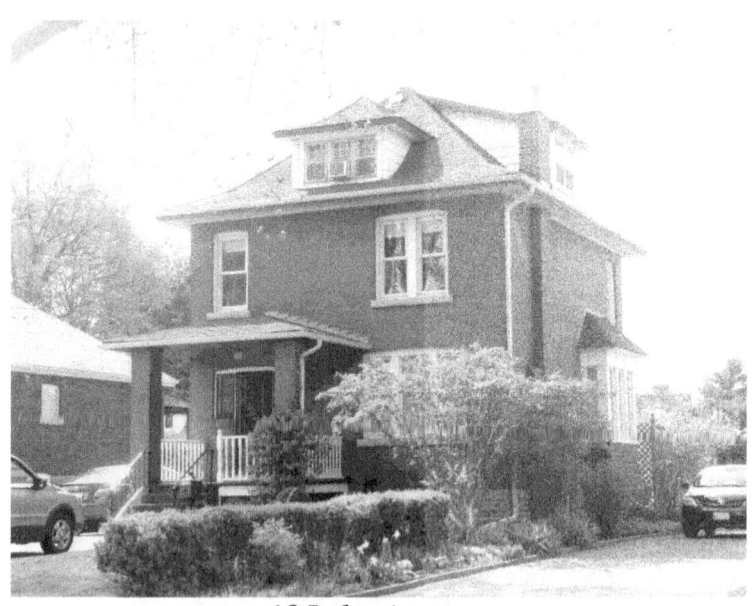

19 Lake Avenue

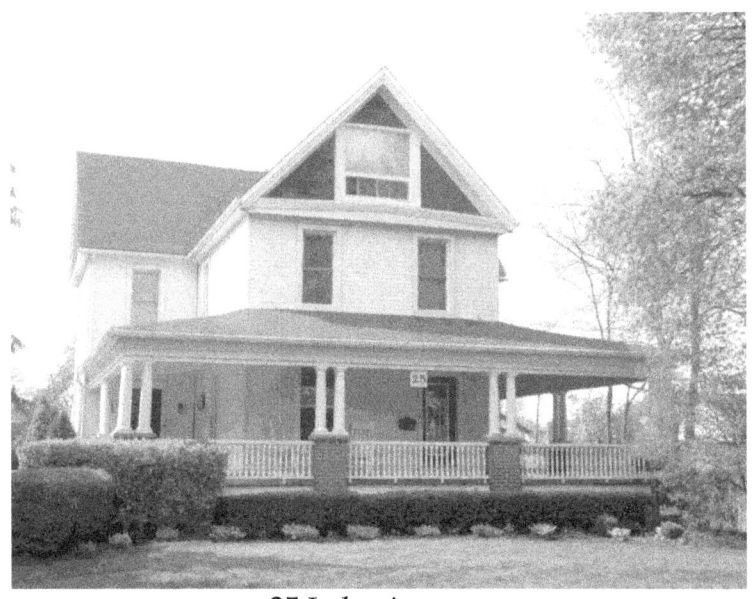

25 Lake Avenue

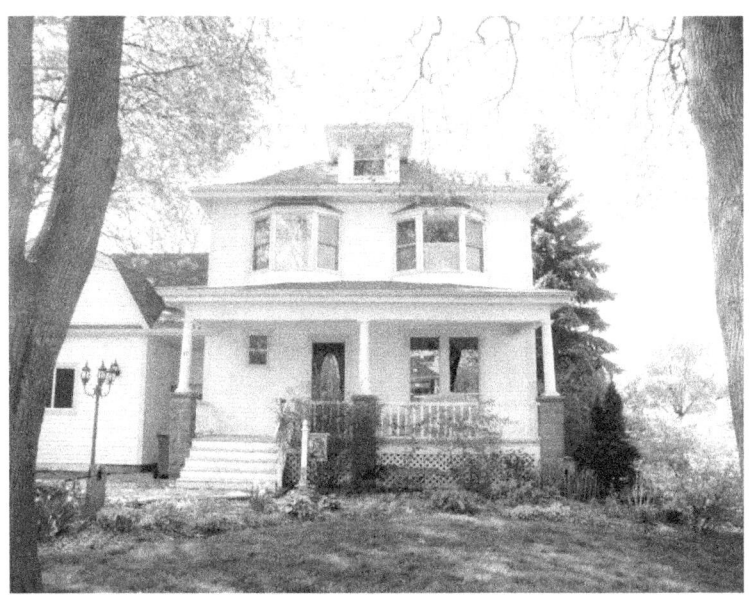

27 Lake Avenue

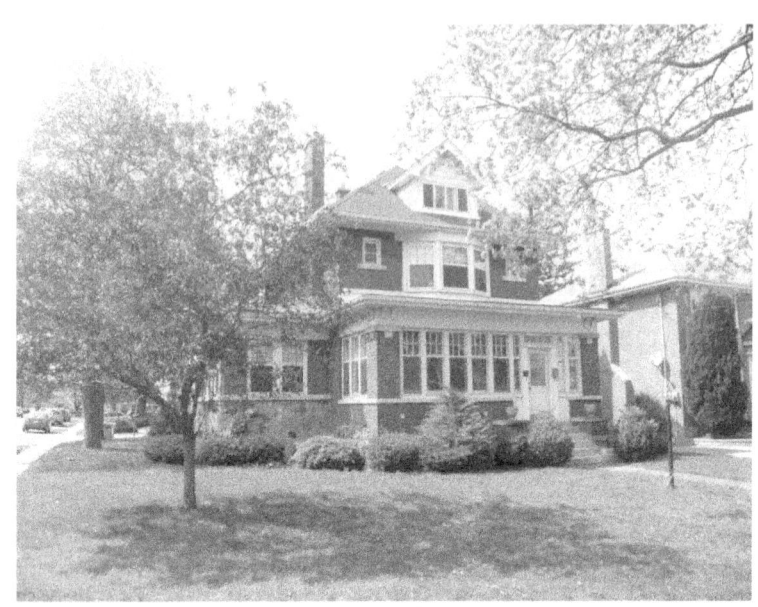

33 Lake Avenue

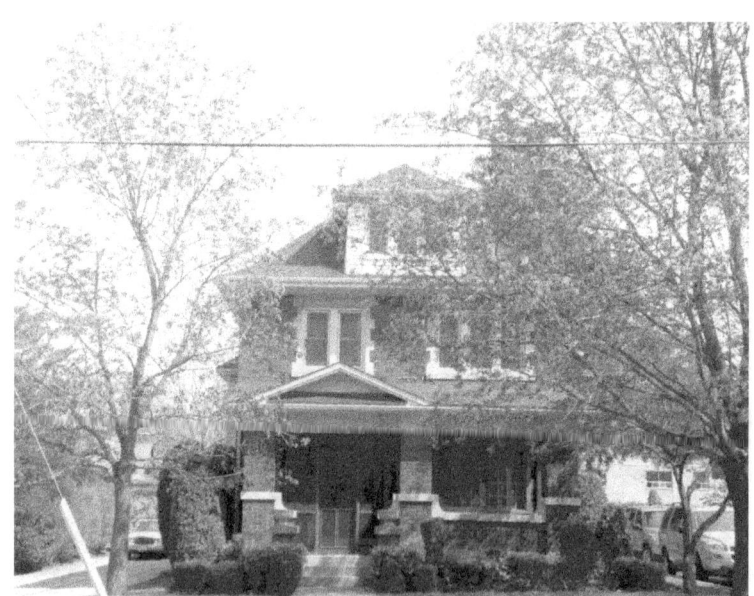

40 Lake Avenue

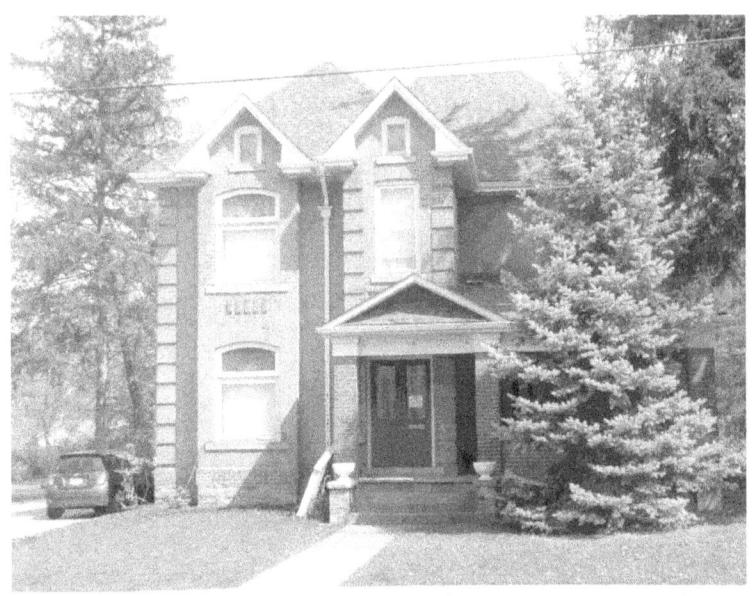

42 Lake Avenue – Roubos Greenhouses (garden plants)

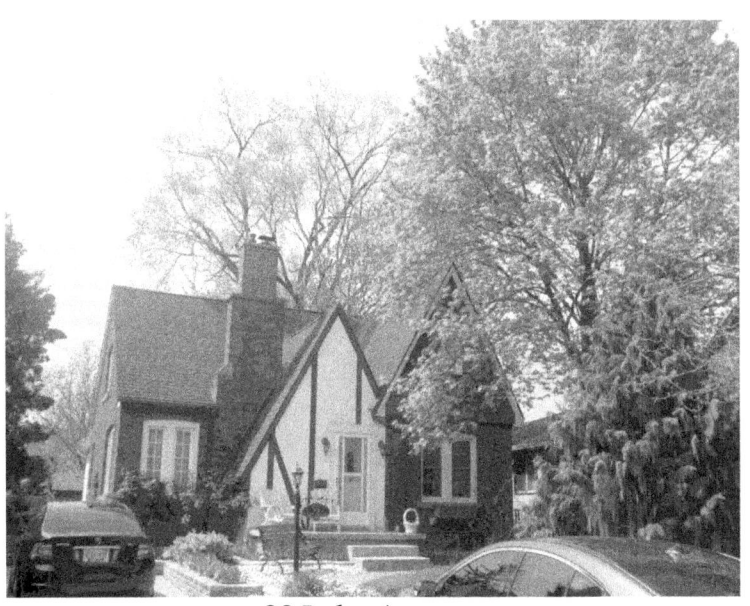

39 Lake Avenue

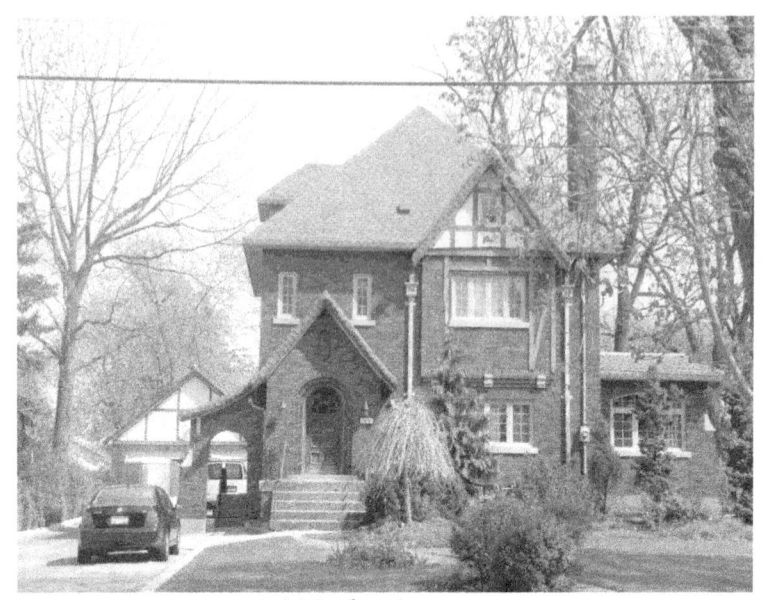
44 Lake Avenue

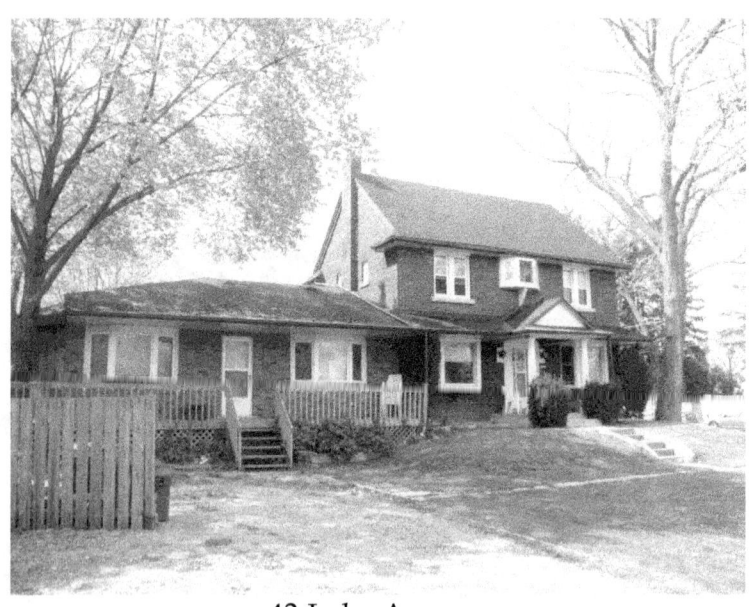
43 Lake Avenue

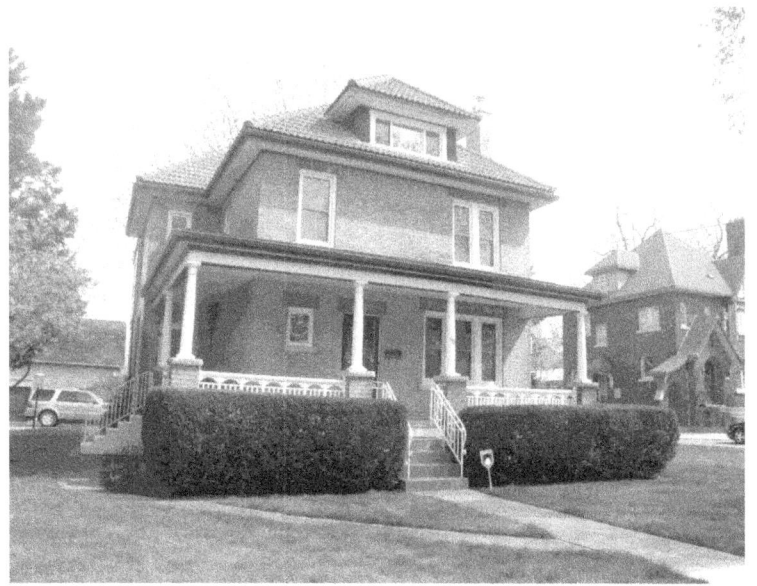

46 Lake Avenue

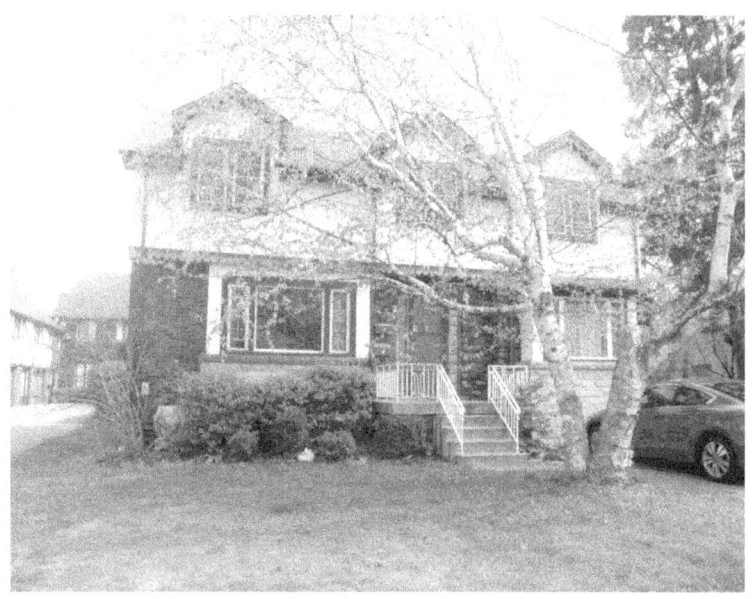

48 Lake Avenue

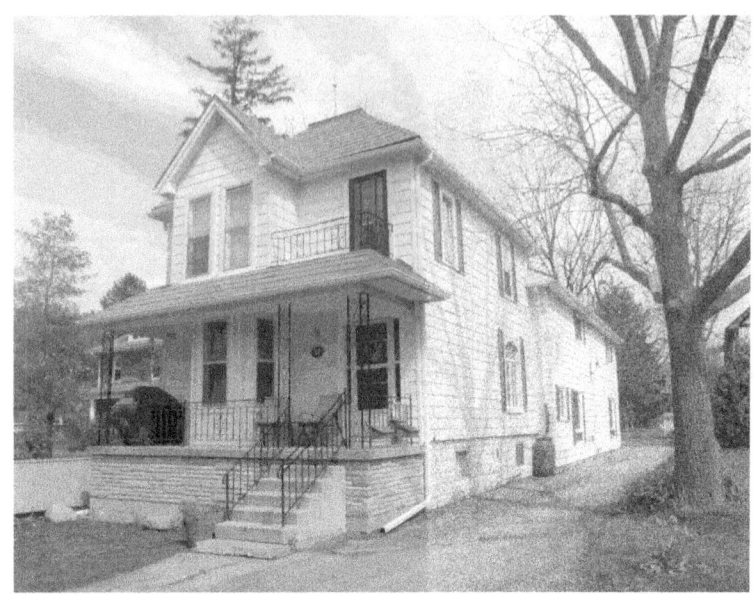

52 Lake Avenue

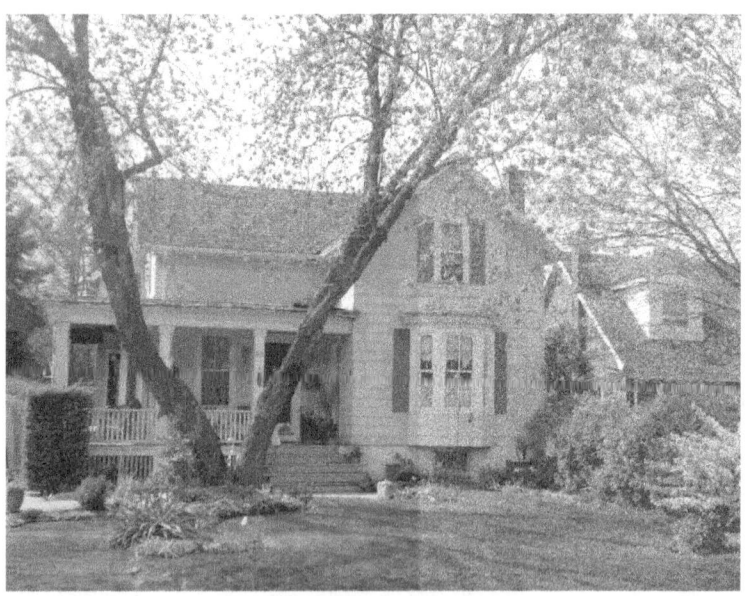

53 Lake Avenue

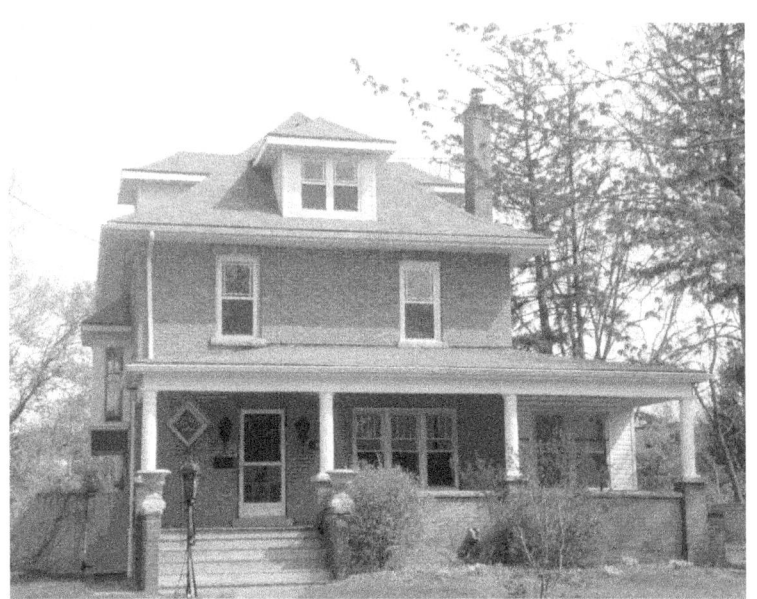

54 Lake Avenue

55 Lake Avenue

57 Lake Avenue

62 Lake Avenue

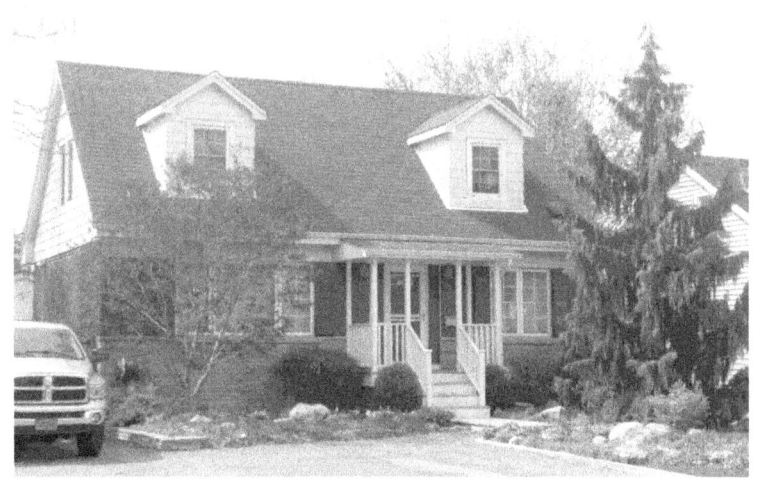

63 Lake Avenue

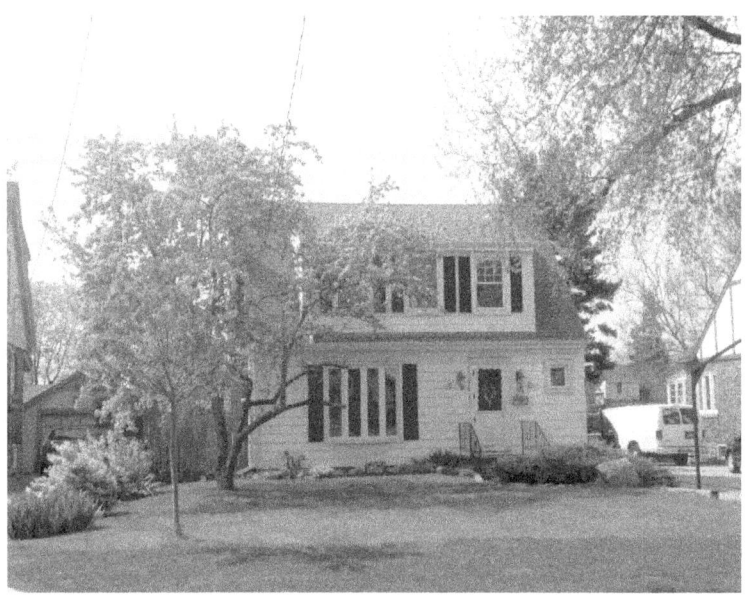

89 Lake Avenue – flowering cherry tree to left

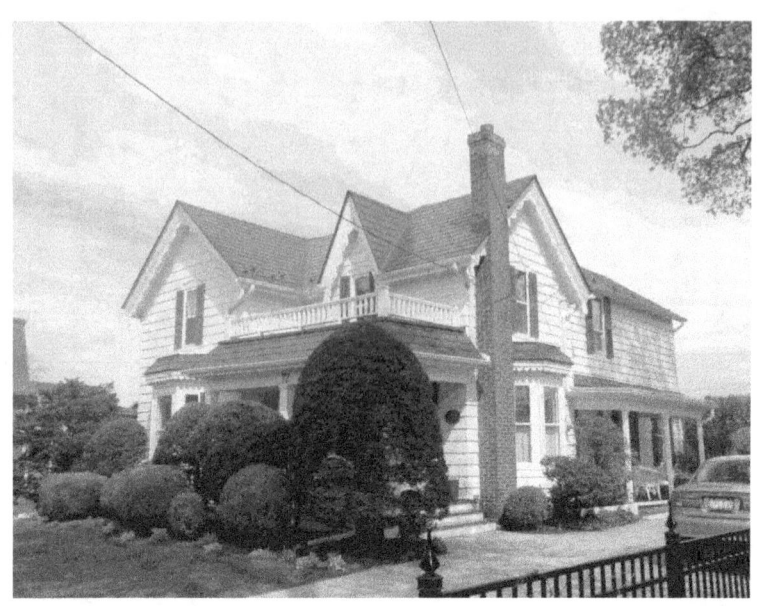

72 Lake Avenue – gingerbread trim

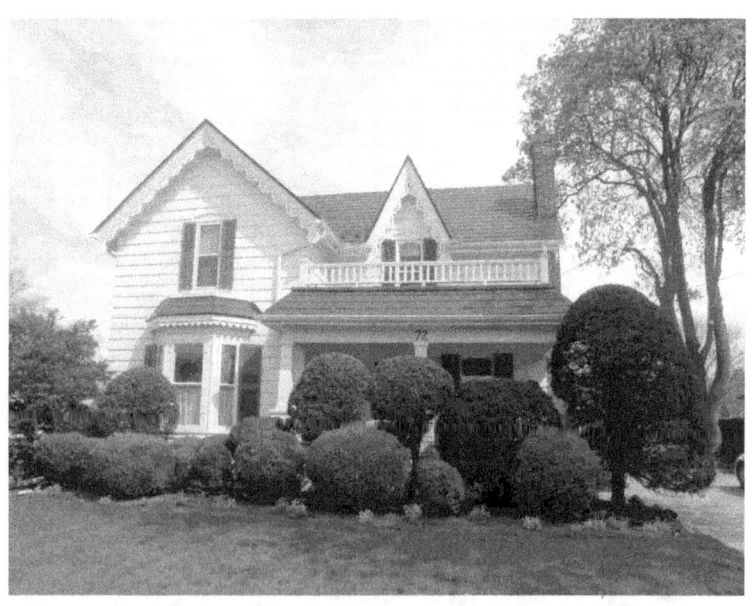

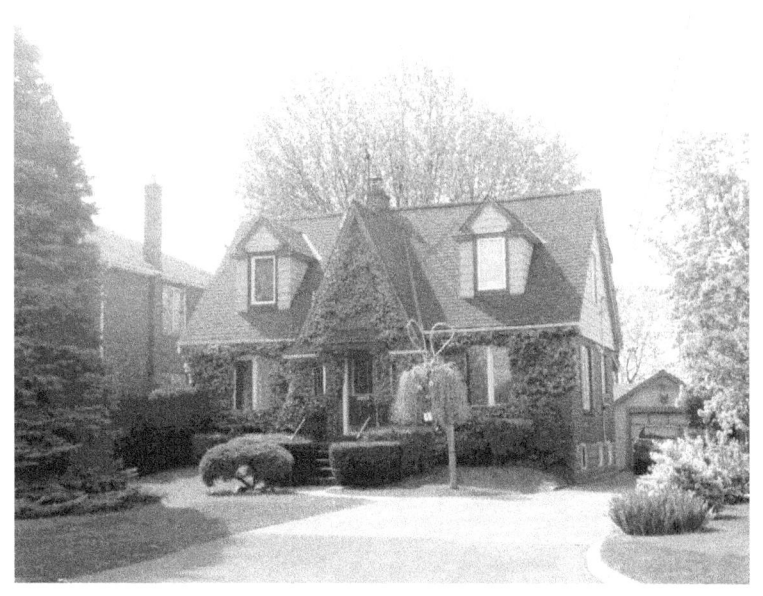

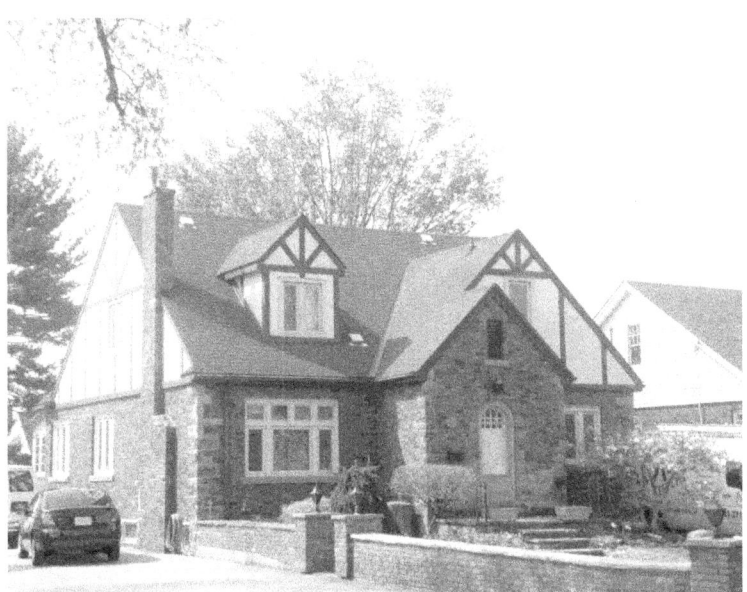

91 Lake Avenue

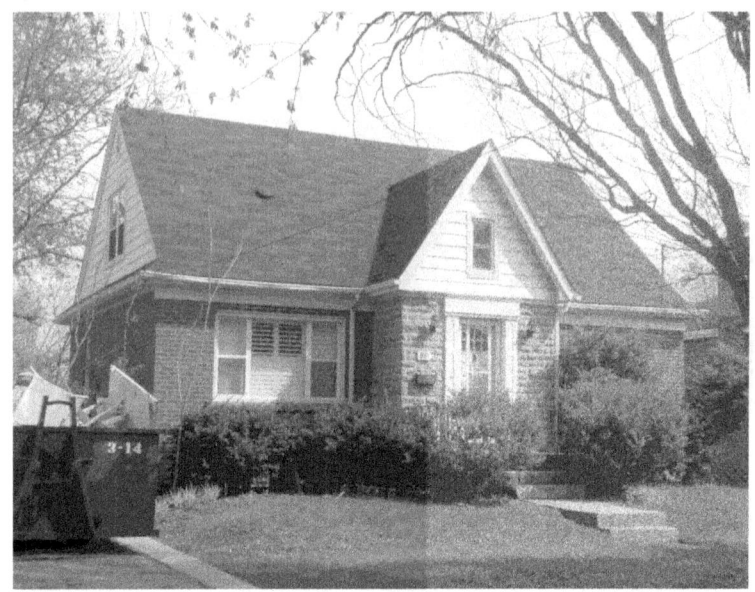

86 Lake Avenue

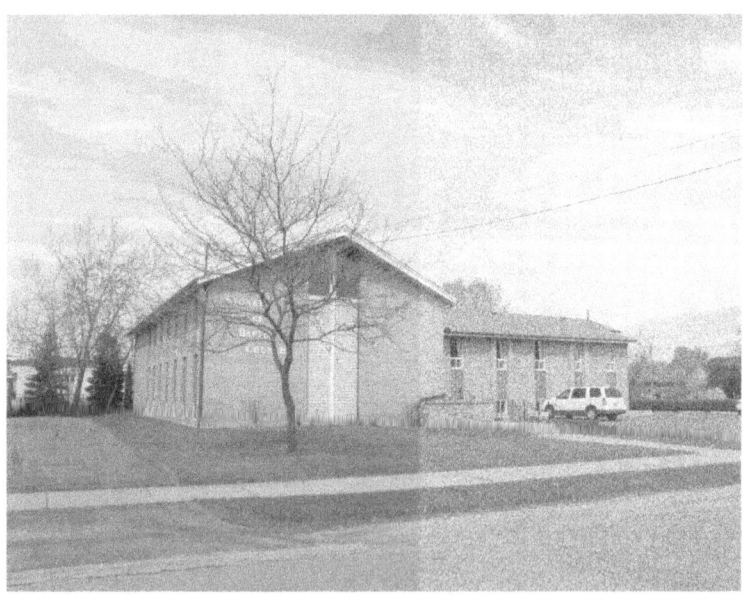

Stoney Creek Baptist Church – 79 Collegiate Avenue at the corner of Gray Road – built in 1958

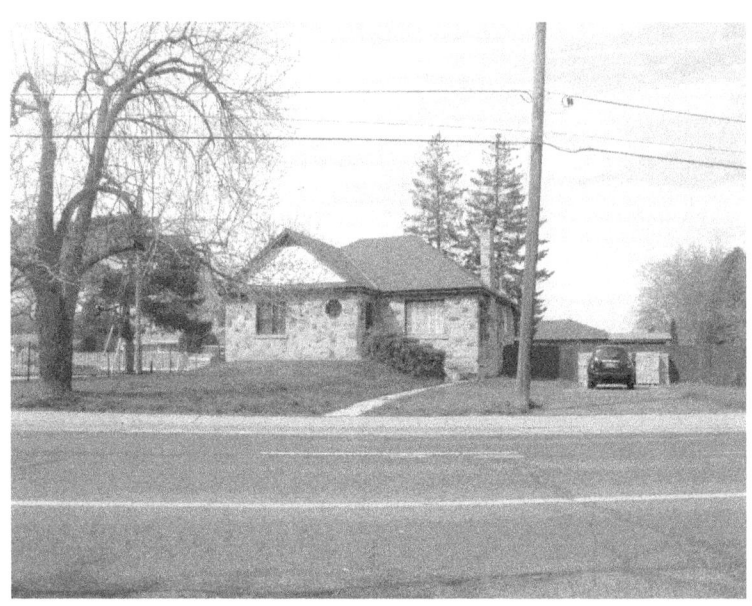

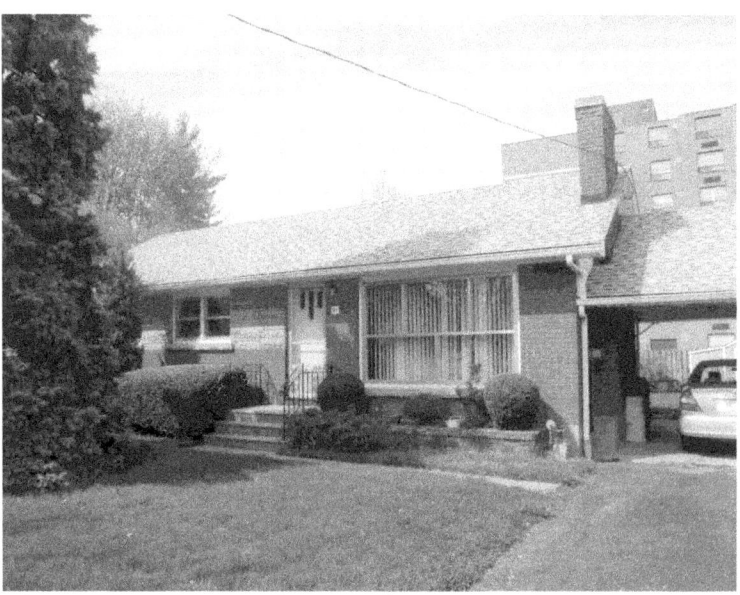

91 Donn Avenue – home of Harris and Denise Raue

www.ingramcontent.com/pod-product-compliance
Lightning Source LLC
Chambersburg PA
CBHW061522180526
45171CB00001B/300